Happy Easter Coloring Book For Kids

This Easter Coloring Activity Book belongs to:

Copyright © 2019 Kids Coloring Books

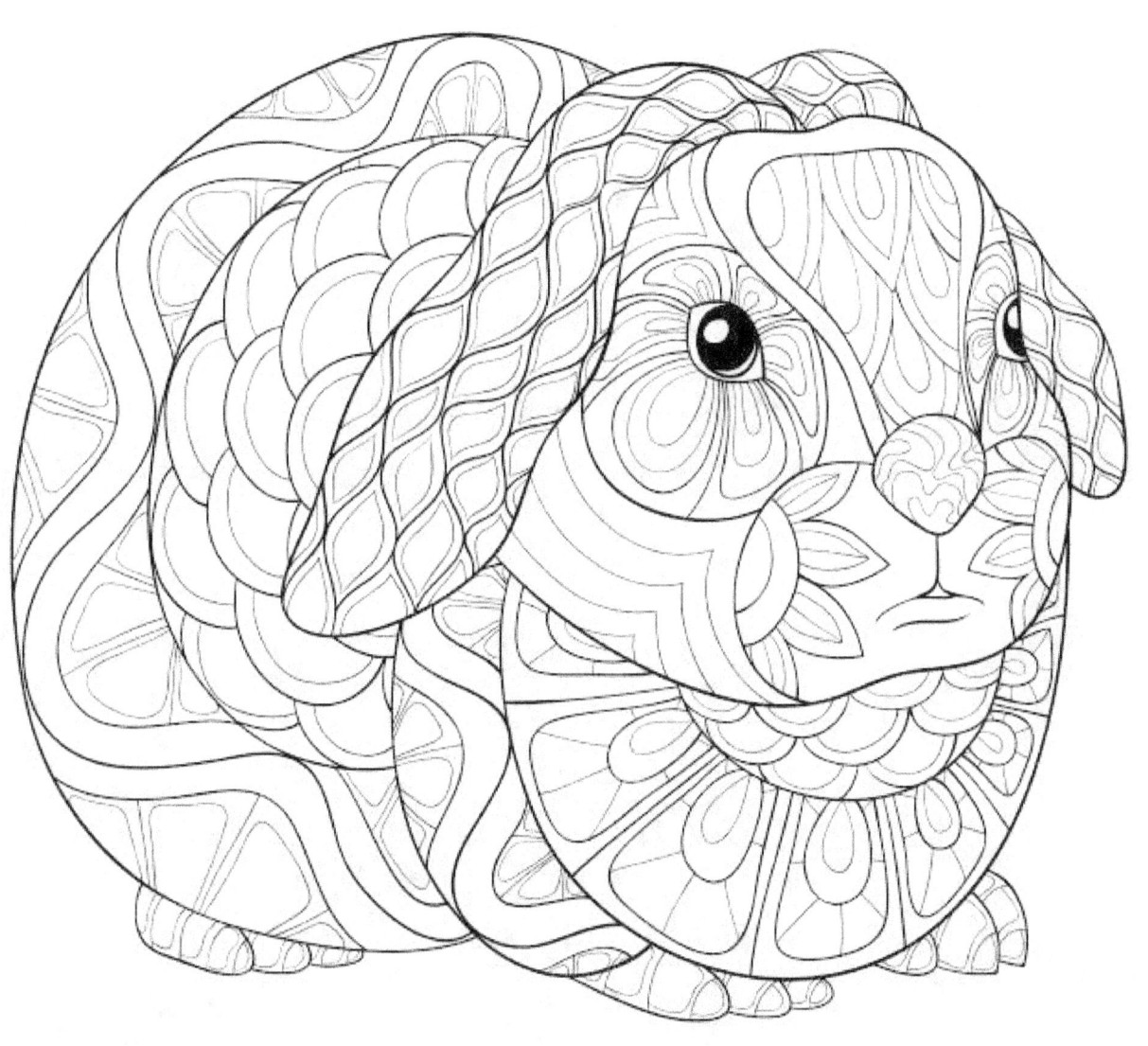

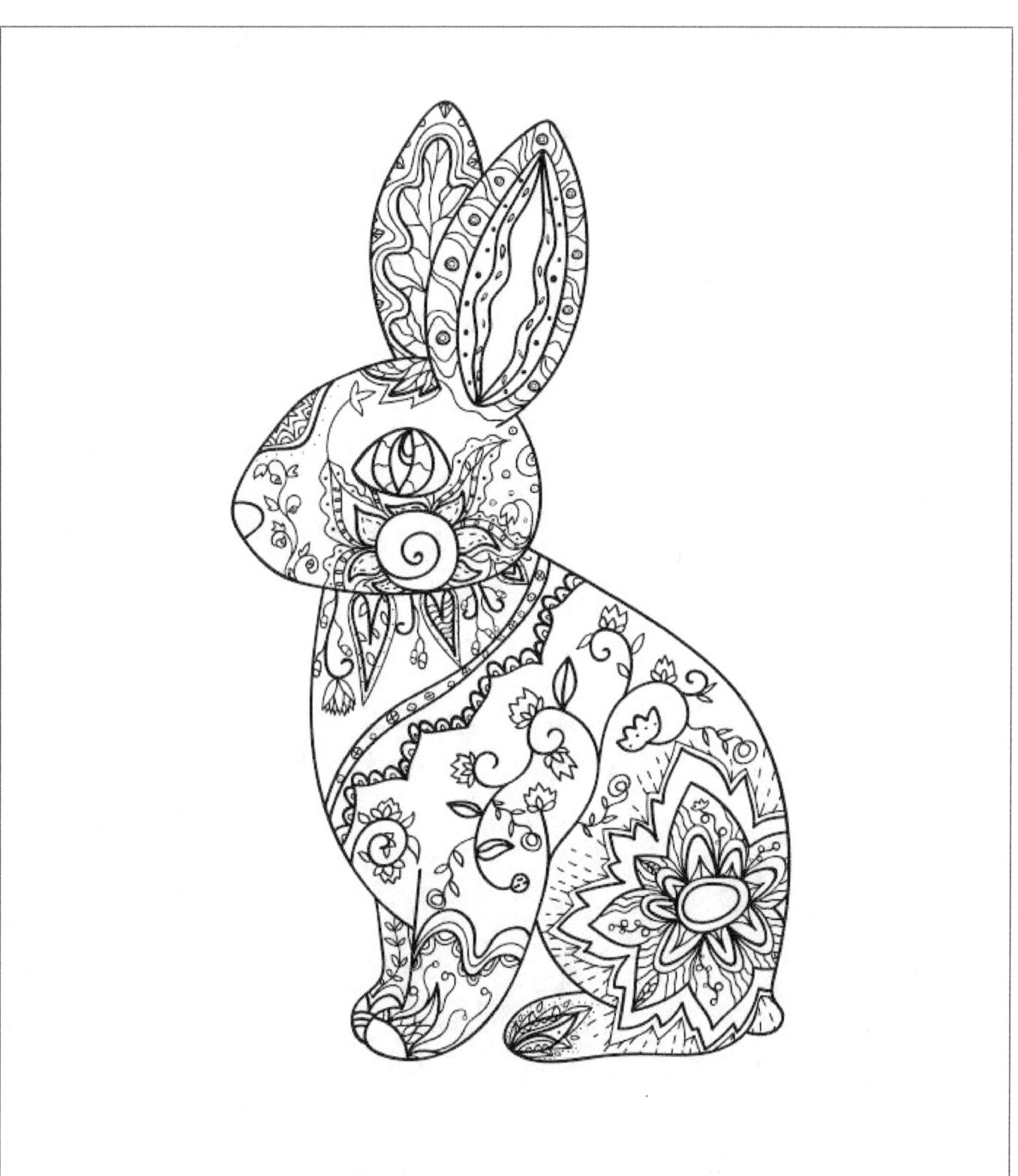

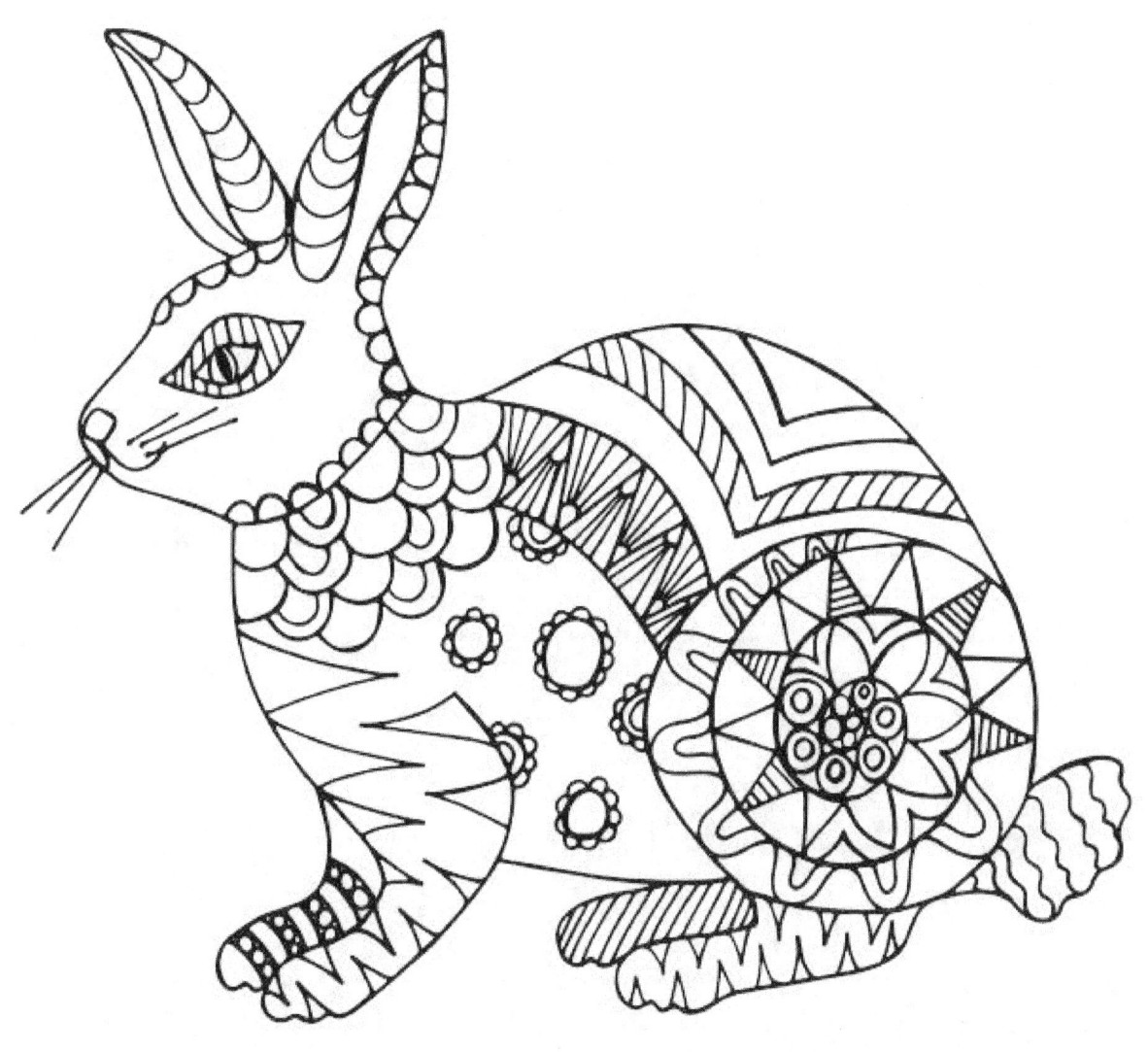

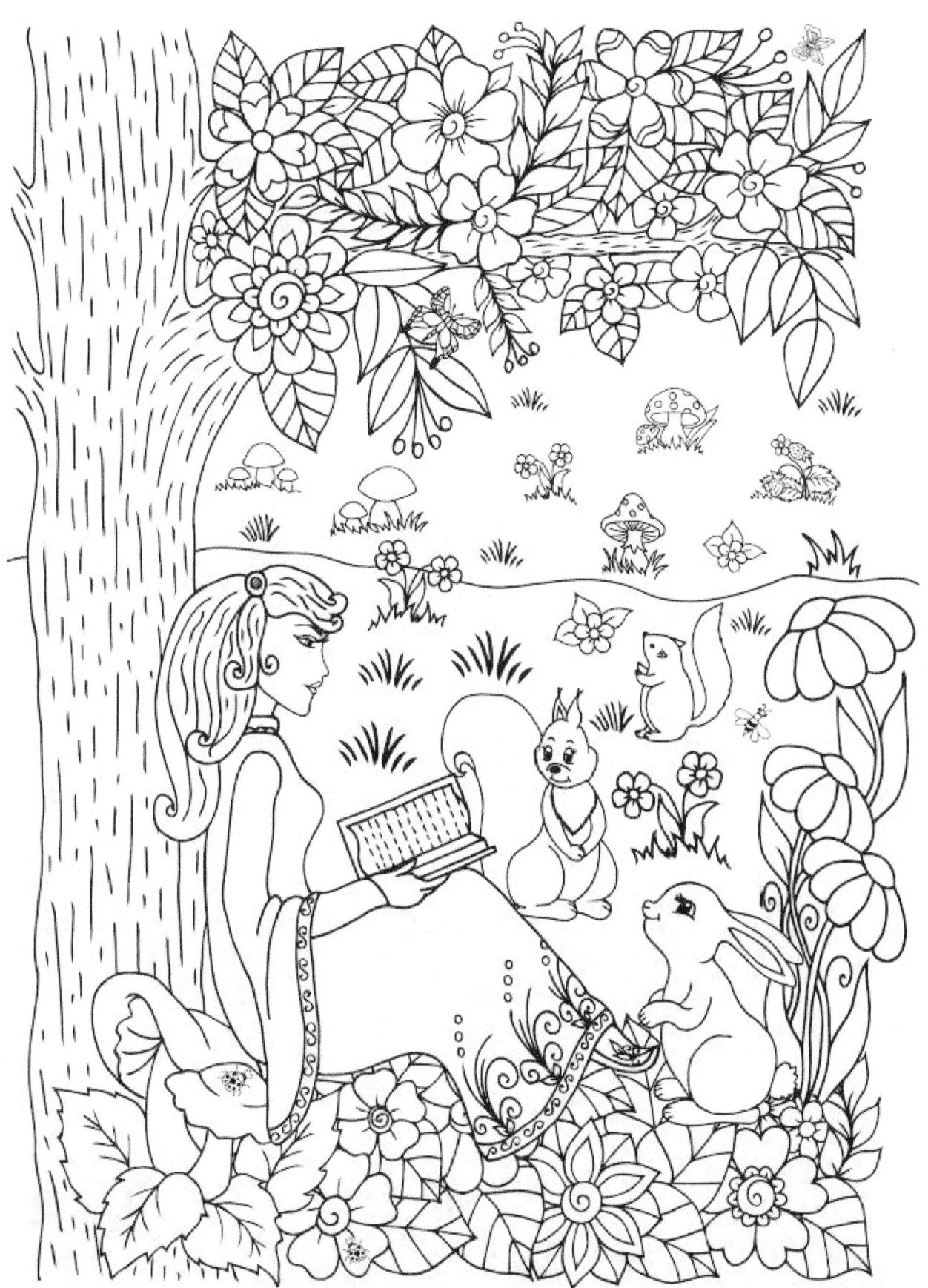

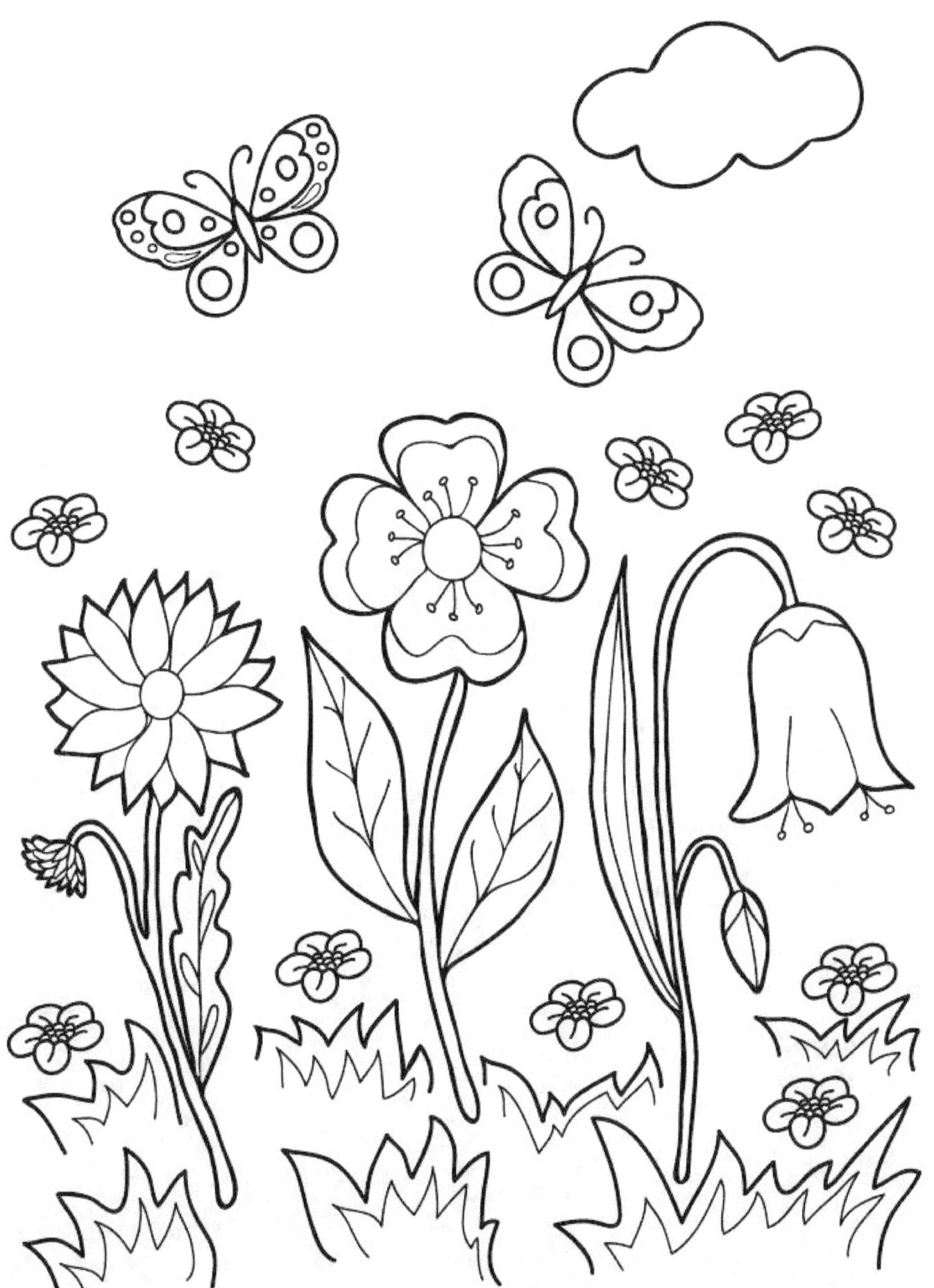

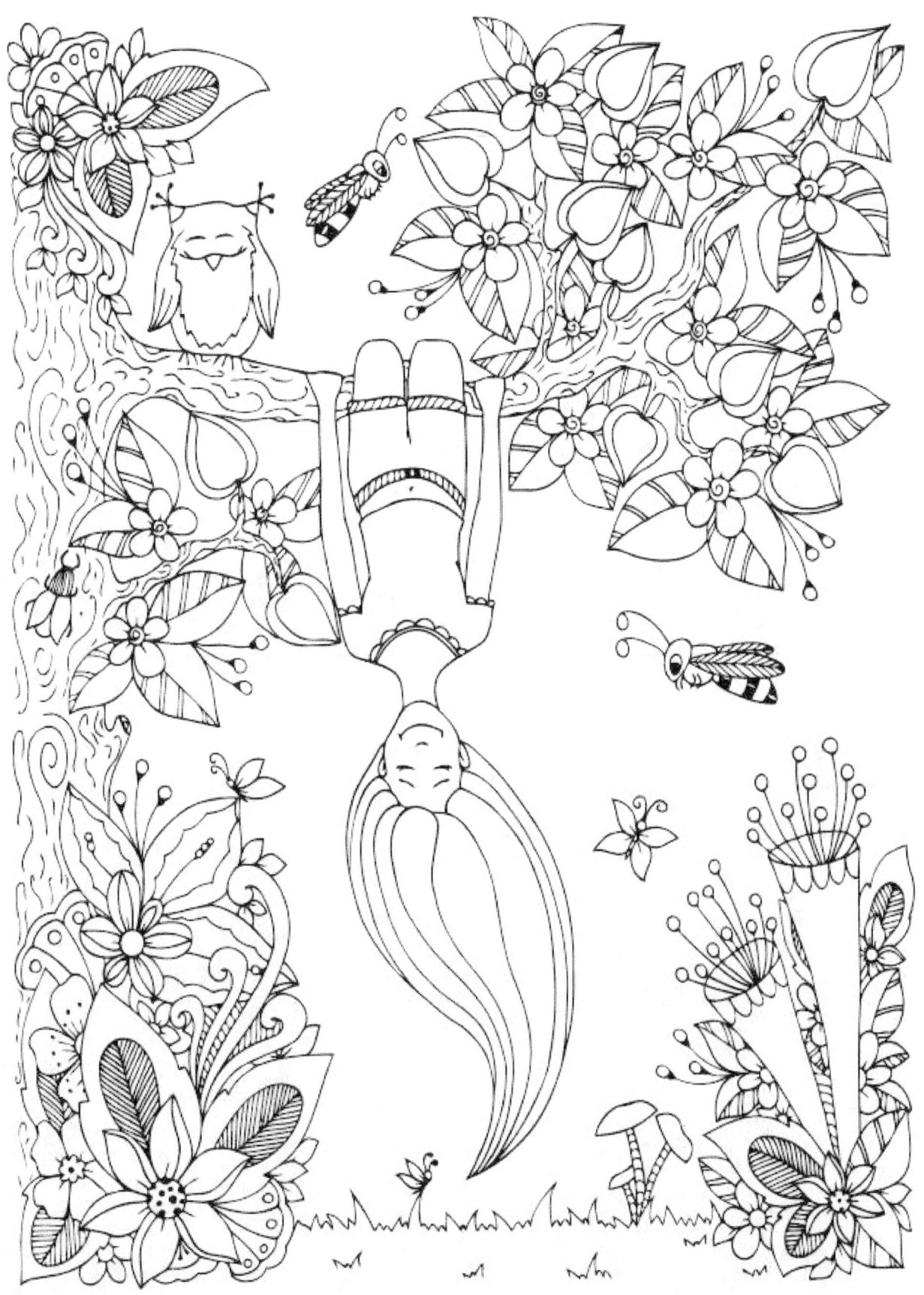

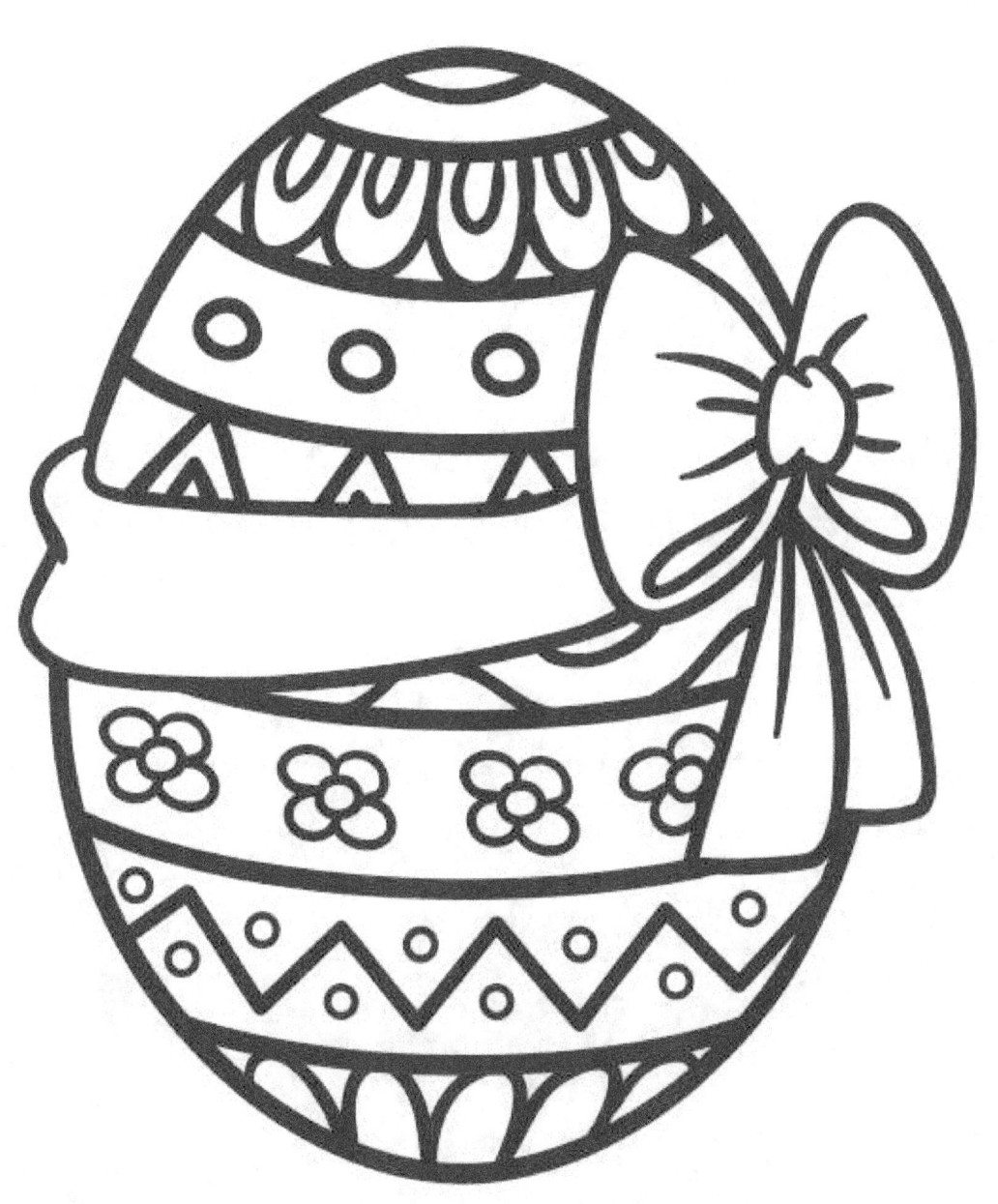

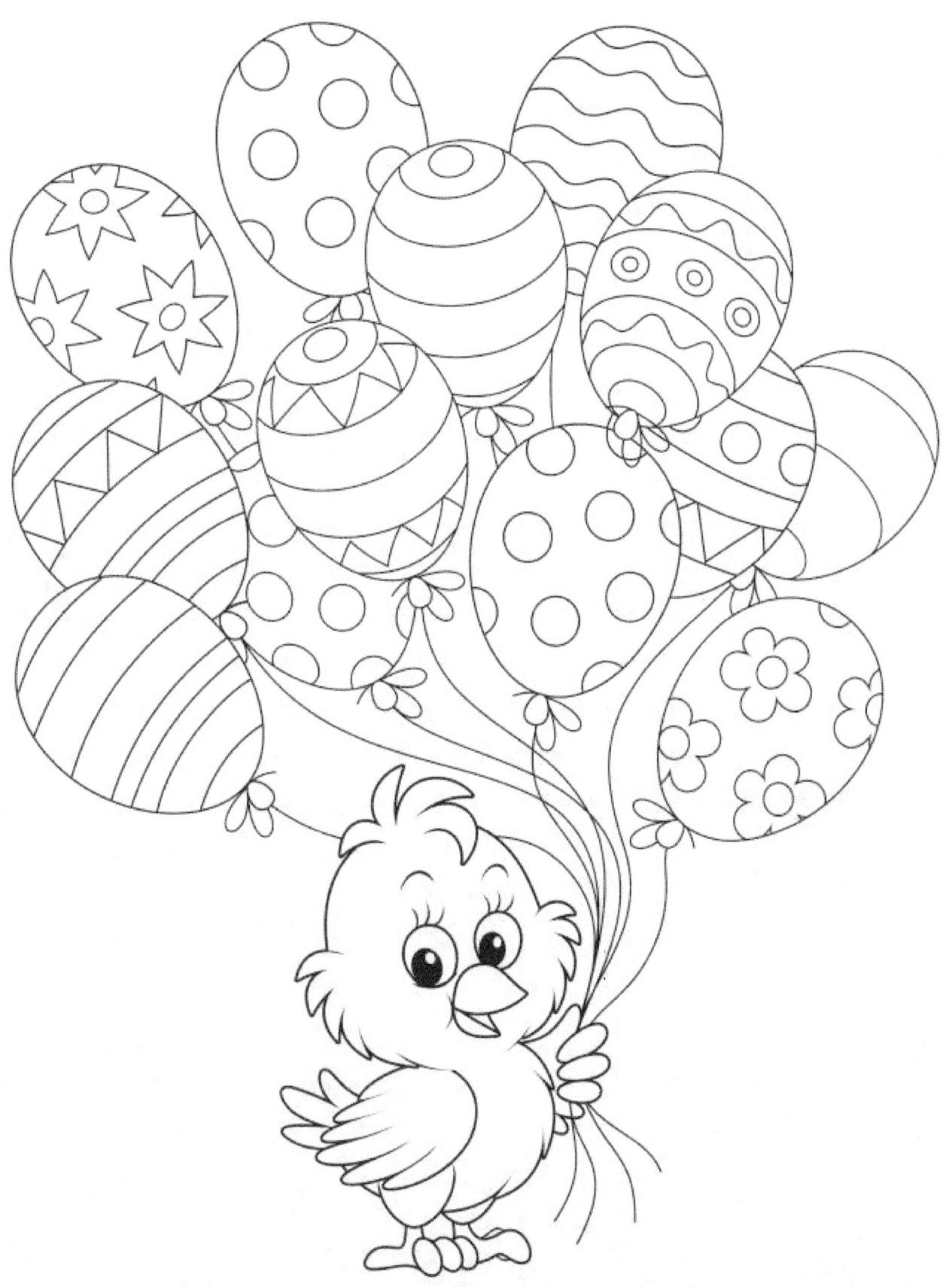

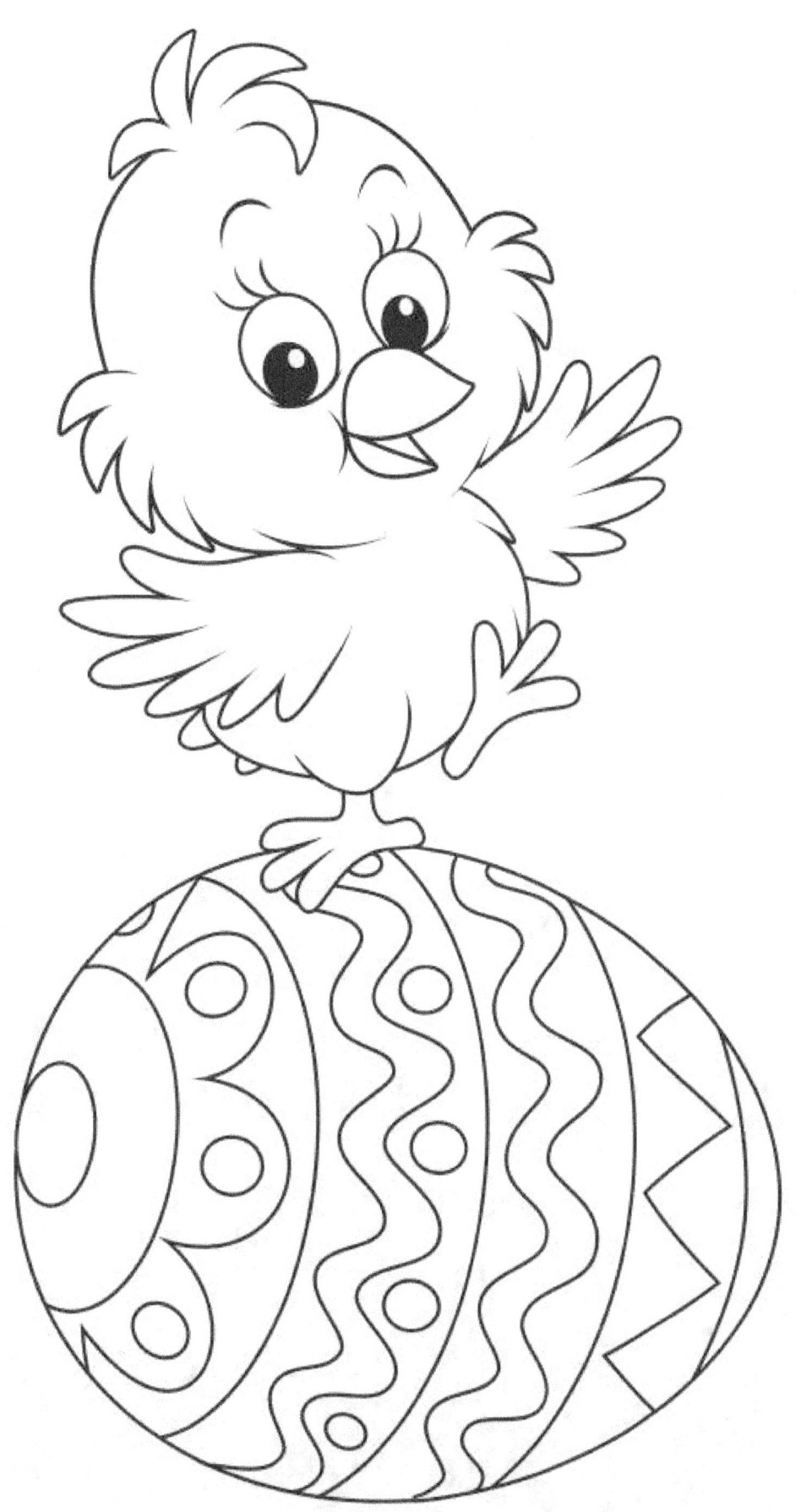

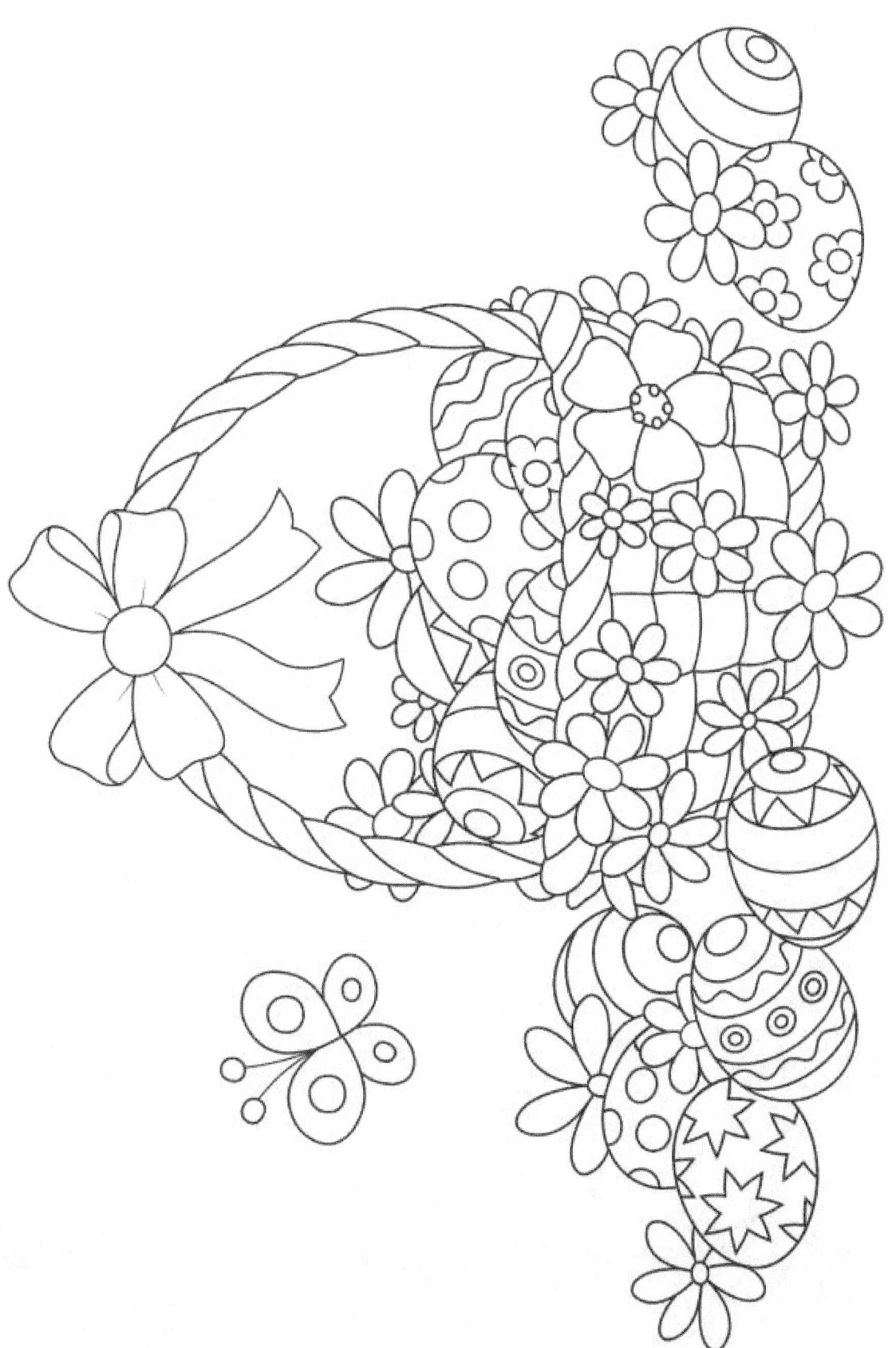

www.ingramcontent.com/pod-product-compliance
Lightning Source LLC
Chambersburg PA
CBHW081623220526
45468CB00010B/2997